Rise: Empowering Women Across Generations

Maarja Hammerberg

Published by Maarja Hammerberg, 2023.

RISE: EMPOWERING WOMEN ACROSS GENERATIONS

First edition. November 14, 2023.

Copyright © 2023 Maarja Hammerberg.

ISBN: 979-8223710073

Written by Maarja Hammerberg.

Also by Maarja Hammerberg

Boundless Trailblazers: Inspiring Stories of Real Women Throughout History
Rise: Empowering Women Across Generations

Table of Contents

To my extraordinary sister, a force of strength and resilience that echoes beyond measure. In a world full of remarkable women, you shine as the most powerful beacon I've ever known. This dedication is a humble tribute to your unwavering spirit, a testament to the indomitable power that defines you. May these words convey the depth of admiration and love I hold for the incredible woman you are.

Introduction

In a world brimming with the echoes of countless untold stories, "Rise: Empowering Women Across Generations" emerges as a beacon illuminating the profound wisdom, resilience, and strength embedded in the fabric of womanhood. Within these pages, you will embark on a transformative journey through the words of extraordinary women who have left an indelible mark on history, echoing their voices across generations.

This compilation is not merely a collection of quotes; it is a celebration of the untapped power residing within the female experience. "Rise" seeks to transcend time and culture, connecting readers with a diverse array of voices that span continents, centuries, and circumstances. The resonating commonality is the fierce determination to rise above adversity, to shatter ceilings, and to pave the way for others to follow.

As you delve into the chapters that follow, you'll encounter the dynamic tapestry of women's lives. From the corridors of power to the intimate realms of love and empathy, from the crucible of challenges to the revolutionary act of breaking stereotypes, each chapter is a testament to the multifaceted strength inherent in every woman. Together, these chapters form a mosaic, illustrating the complexity and beauty of the female experience.

"Rise" is an invitation to explore, reflect, and be inspired. The pages within offer more than just words—they offer a reservoir of

guidance, encouragement, and the realization that, regardless of where you stand today, you are part of an unbroken lineage of strength and resilience.

So, open these pages with a heart ready to be stirred, a mind prepared to be expanded, and a spirit poised to rise. The stories, quotes, and insights contained herein are not confined to the past; they reverberate in the present, shaping the narratives of the future. As we embark on this collective journey, let "Rise" be the catalyst for your own empowerment and the catalyst for a world where the voices of women, echoing across generations, continue to shape our shared destiny.

Chapter 1: Women in Leadership

In the tapestry of time, the first chapter of "Rise: Empowering Women Across Generations" unveils a gallery of quotes by trailblazing women who have etched their names in the annals of leadership. These are the voices of visionaries, activists, and innovators who have risen to the summit of influence, leaving an indomitable imprint on the world.

As you immerse yourself in the wisdom of these leaders, you will encounter a symphony of voices guiding you through the nuances of power, responsibility, and the relentless pursuit of a better future. The women featured in this chapter have not merely navigated the corridors of authority; they have reshaped them, challenging preconceived notions and demanding a seat at the table.

From political arenas to boardrooms, these women have defied the constraints of societal expectations, proving that leadership is not confined to gender but is an intrinsic quality that transcends boundaries. The quotes within these pages are not just affirmations of achievement; they are beacons lighting the path for aspiring leaders, regardless of their gender, to step into their own authority.

Each quote resonates with the conviction that leadership is a force for positive change—a catalyst for progress that knows no gender bias. Through the experiences of these women, readers will glean insights into the challenges faced, the victories celebrated, and the enduring lessons that paved the way for future generations.

"Rise" challenges you to reflect on your own leadership potential, urging you to recognize that the mantle of influence is not reserved for a select few but is a birthright bestowed upon every individual, irrespective

of gender. As you navigate the empowering quotes within this chapter, envision yourself not merely as a spectator but as a participant in the ongoing narrative of women shaping the world.

So, let the words of these leaders resonate within you, and may they kindle the flames of inspiration, propelling you to ascend the peaks of your own leadership journey. The chapter on Women in Leadership is not just a testament to the achievements of remarkable women; it is a call to action for you to embrace your inherent power and rise to the challenges that await, forging a path for generations yet to come.

1. "A LEADER IS NOT defined by the position she holds but by the impact she makes." - Michelle Obama

2. "TRUE LEADERSHIP is about empowering others to rise with you." - Malala Yousafzai

3. "IN LEADERSHIP, courage is the currency of change." - Angela Merkel

4. "A WOMAN'S STRENGTH is the catalyst for transformative leadership." - Oprah Winfrey

5. "LEADERSHIP IS NOT about being in charge. It's about taking care of those in your charge." - Mary Elizabeth Winstead

6. "THE WORLD NEEDS leaders who lead with kindness, strength, and unwavering integrity." - Ellen Johnson Sirleaf

7. "A GREAT LEADER is one who can turn her vision into reality and inspire others to join her on the journey." - Aung San Suu Kyi

8. "LEADERSHIP IS NOT about standing in the spotlight; it's about illuminating the path for others." - Sheryl Sandberg

9. "TRUE EMPOWERMENT comes from lifting others, especially when you have the strength to carry them higher." - Emma Watson

10. "A WOMAN'S VOICE in leadership is a powerful instrument for change." - Hillary Clinton

11. "LEADERSHIP IS THE art of giving people a platform for spreading ideas that work." - Melinda Gates

12. "GREAT LEADERS ARE not afraid to embrace vulnerability; it's the birthplace of innovation and connection." - Brené Brown

13. "THE MEASURE OF a leader is not the number of followers but the number of leaders she creates." - Indra Nooyi

14. "A WOMAN IN LEADERSHIP is a beacon of hope, a testament to the limitless potential within us all." - Jacinda Ardern

15. "LEADERSHIP IS ABOUT making others better as a result of your presence and making sure that impact lasts in your absence." - Sheryl WuDunn

16. "THE POWER OF A woman leader lies in her ability to turn challenges into opportunities for growth." - Ginni Rometty

17. "LEADERSHIP IS NOT about the next election; it's about the next generation." - Gloria Steinem

18. "A LEADER'S STRENGTH is not in her ability to control, but in her capacity to empower." - Diane von Furstenberg

19. "IN LEADERSHIP, it's not about the title; it's about the impact you make on those around you." - Ursula Burns

20. "THE BEST LEADERS are those most interested in surrounding themselves with assistants and associates smarter than they are." - John C. Maxwell

21. "LEADERSHIP IS ABOUT being of service to others, not being served by others." - Jody Williams

22. "A WOMAN'S LEADERSHIP is a symphony of strength, grace, and resilience." - Kamala Harris

23. "LEADERSHIP IS NOT a position or a title; it is an action and an example." - Cory Booker

24. "IN LEADERSHIP, there is no finish line. It's a continuous journey of growth and impact." - Greta Thunberg

25. "A LEADER'S LEGACY is not in what she accumulates but in what she contributes to the world." - Angela Davis

26. "TRUE LEADERS DON'T create followers; they create more leaders." - Mother Teresa

27. "LEADERSHIP IS NOT about being perfect; it's about being authentic and willing to learn." - Arianna Huffington

28. "A LEADER'S GREATEST achievement is when her success becomes an inspiration for others to dream more, do more, and become more." - Eleanor Roosevelt

29. "THE STRENGTH OF a woman in leadership lies in her ability to navigate challenges with resilience and grace." - Christine Lagarde

30. "LEADERSHIP IS ABOUT understanding that we are all in this together and working toward a common goal." - Emma Gonzalez

31. "A WOMAN LEADER is a bridge between dreams and reality, turning aspirations into achievements." - Angela Merkel

32. "LEADERSHIP IS NOT about being the loudest voice in the room; it's about amplifying the voices of others." - Tracee Ellis Ross

33. "THE ESSENCE OF leadership is the ability to see beyond the challenges and envision a brighter future." - Oprah Winfrey

34. "LEADERSHIP IS NOT about ego; it's about empathy and creating a sense of belonging for all." - Jacinda Ardern

35. "A WOMAN'S LEADERSHIP is a force that transforms obstacles into stepping stones." - Malala Yousafzai

36. "LEADERSHIP IS ABOUT making a positive impact on the lives of others and leaving the world better than you found it." - Michelle Obama

37. "A TRUE LEADER IS one who builds a path for others to follow, not just for herself." - Indira Gandhi

38. "LEADERSHIP IS NOT about telling people what to do; it's about showing them how it's done." - Mary Barra

39. "THE STRENGTH OF a woman leader lies in her ability to turn setbacks into comebacks." - Serena Williams

40. "IN LEADERSHIP, the most empowering act is to listen, understand, and uplift the voices of those around you." - Ruth Bader Ginsburg

Chapter 2: Love and Empathy

In the tapestry of emotions, the second chapter of "Rise: Empowering Women Across Generations" unfurls a canvas painted with the hues of love, compassion, and empathy. This chapter transcends the boundaries of time, weaving together the voices of women who have harnessed the profound power of emotional intelligence to create lasting impact and forge meaningful connections.

As you embark on this chapter's journey, prepare to be immersed in the wisdom of women who have not only conquered realms of the heart but have also wielded love and empathy as transformative tools in their personal and societal landscapes. These quotes are not mere expressions of sentiment; they are profound reflections on the ability of love to transcend differences, heal wounds, and pave the way for a more compassionate world.

"Love and Empathy" beckons you to explore the depths of your own emotional reservoirs, challenging you to cultivate kindness and understanding in a world that often hungers for connection. Through the lens of these women's experiences, you will discover that love is not a passive force but an active agent of change, capable of dismantling barriers and fostering unity.

1. "The truest strength lies not in the ability to conquer, but in the willingness to understand and love." - Maya Angelou

2. "EMPATHY IS THE bridge that connects hearts across the widest chasms of difference." - Jane Goodall

3. "IN A WORLD THAT often demands toughness, remember that kindness is a revolutionary act." - Audre Lorde

4. "LOVE IS THE MOST formidable force; it can transform the hardest hearts and soften the toughest paths." - Bell Hooks

5. "EMPATHY IS NOT a weakness; it's a superpower that allows us to see the world through another's eyes." - Chimamanda Ngozi Adichie

6. "THE COURAGE TO love is the courage to be vulnerable, and in that vulnerability, we find our true strength." - Brene Brown

7. "EMPATHY IS NOT about fixing someone's problems; it's about standing with them in their journey." - Glennon Doyle

8. "LOVE IS THE UNIVERSAL language that transcends borders, cultures, and time." - Princess Diana

9. "EMPATHY IS THE antidote to judgment, and in its embrace, we find the healing balm for the wounds of misunderstanding." - Thich Nhat Hanh

10. "IN A WORLD FULL of noise, love is the quiet force that speaks to the soul." - Rupi Kaur

11. "EMPATHY IS NOT just about feeling for others; it's about acting for the greater good of all." - Dalai Lama

12. "LOVE IS THE THREAD that weaves the tapestry of humanity, connecting us all in a shared story of compassion." - Desmond Tutu

13. "EMPATHY IS THE key that unlocks the door to understanding, allowing us to see the beauty in our shared humanity." - Helen Keller

14. "LOVE IS NOT A TRANSACTION; it is a gift freely given, binding us together in the tapestry of existence." - bell hooks

15. "EMPATHY IS THE art of stepping into someone else's shoes, not just to understand their journey but to walk alongside them." - Oprah Winfrey

16. "LOVE IS THE FORCE that propels us forward, enabling us to transcend our limitations and reach for the stars." - Mae Jemison

17. "EMPATHY IS THE cornerstone of a compassionate society, where understanding replaces judgment, and love conquers fear." - Malala Yousafzai

18. "LOVE IS THE ALCHEMY that turns the ordinary into the extraordinary, the mundane into the magical." - Elizabeth Gilbert

19. "EMPATHY IS THE language of the heart, speaking volumes without the need for words." - Mother Teresa

20. "IN A WORLD THIRSTING for connection, love is the wellspring that nourishes the soul." - Frida Kahlo

21. "EMPATHY IS NOT just about feeling sorry for someone; it's about standing with them in solidarity and working together for change." - Michelle Obama

22. "LOVE IS THE FORCE that compels us to reach beyond ourselves, to embrace the diversity of the human experience." - Maya Angelou

23. "EMPATHY IS THE compass that guides us through the vast landscapes of human emotion, helping us navigate the complexities of

the heart." - Brené Brown

24. "LOVE IS THE CATALYST for courage, emboldening us to face adversity with open hearts and unwavering resilience." - Coretta Scott King

25. "EMPATHY IS THE foundation upon which we build bridges of understanding, dismantling the walls that divide us." - Elie Wiesel

26. "LOVE IS THE ANTIDOTE to hatred, the beacon that lights the path to a more compassionate and inclusive world." - Nelson Mandela

27. "EMPATHY IS THE cornerstone of justice, ensuring that every voice is heard and every story is acknowledged." - Ruth Bader Ginsburg

28. "LOVE IS THE CURRENCY of change, a transformative power that shapes societies and reshapes destinies." - Angela Davis

29. "EMPATHY IS THE ability to see beyond the surface and recognize the shared humanity that unites us all." - Audre Lorde

30. "LOVE IS THE FORCE that binds us together, transcending the

boundaries that seek to keep us apart." - Wangari Maathai

31. "EMPATHY IS THE foundation of meaningful relationships, creating bridges that withstand the tests of time and tribulation." - Maya Angelou

32. "LOVE IS THE COURAGE to be vulnerable, to open ourselves to the beauty and pain of the human experience." - Thich Nhat Hanh

33. "EMPATHY IS THE heartbeat of humanity, pulsating with the rhythm of understanding and compassion." - Desmond Tutu

34. "LOVE IS THE FIRE that fuels our journey, lighting the way even in the darkest of times." - bell hooks

35. "EMPATHY IS THE silent force that compels us to reach across divides, to connect with the hearts of others." - Dalai Lama

36. "LOVE IS THE THREAD that binds us in a tapestry of shared experiences, weaving together the fabric of our interconnected lives." - Rupi Kaur

37. "EMPATHY IS THE gentle touch that heals wounds, the soothing balm that brings comfort to troubled souls." - Glennon Doyle

38. "LOVE IS THE ANCHOR that grounds us in the storms of life, providing stability in the face of uncertainty." - Princess Diana

39. "EMPATHY IS THE language that transcends words, allowing hearts to communicate in the universal dialect of compassion." - Helen Keller

40. "LOVE IS THE LEGACY we leave behind, an enduring gift that outlasts the passage of time." - Maya Angelou

AS YOU ABSORB THE PROFOUND insights within the "Love and Empathy" chapter, may you be inspired to embrace the transformative power of love, cultivating empathy as a guiding force in your own journey and contributing to the creation of a more compassionate and connected world. For in the realm of emotions, the ability to love and empathize knows no boundaries, echoing across generations and shaping the narrative of a shared humanity.

Chapter 3: Overcoming Challenges

In the tapestry of resilience, the third chapter of "Rise: Empowering Women Across Generations" unveils a gallery of quotes by women who have faced and triumphed over various challenges. These are the voices of strength, courage, and tenacity that echo through the corridors of time, offering solace, hope, and inspiration to those navigating their own tumultuous paths.

As you immerse yourself in the wisdom of these women, prepare to embark on a journey of overcoming obstacles, breaking through barriers, and emerging victorious against all odds. The quotes within this chapter are not just affirmations of triumph; they are beacons lighting the way for those grappling with adversity, proving that resilience is not merely a trait but a force that propels us forward.

1. "The measure of success is not whether you have a tough problem to deal with, but whether it's the same problem you had last year." - Eleanor Roosevelt

2. "IN THE FACE OF adversity, a woman's strength is revealed – resilient, unyielding, and unstoppable." - Malala Yousafzai

3. "CHALLENGES ARE not roadblocks; they are stepping stones to greatness, forging a path to a stronger, wiser you." - Oprah Winfrey

4. "THE MOST BEAUTIFUL people we have known are those who have known defeat, known suffering, known struggle, known loss, and have found their way out of those depths." - Elisabeth Kübler-Ross

5. "ADVERSITY IS THE canvas on which the masterpiece of resilience is painted." - Maya Angelou

6. "THE HUMAN SPIRIT is stronger than anything that can happen to it. It has the strength to endure and the courage to confront the darkest moments." - Victor Frankl

7. "LIFE'S CHALLENGES are not obstacles but opportunities for growth, transformation, and the unveiling of your true potential." - Arianna Huffington

8. "A WOMAN'S JOURNEY is a testament to her resilience. In every stumble, she finds the strength to rise and continue the climb." - Michelle Obama

9. "STRENGTH DOES NOT come from the body. It comes from the will and determination to face challenges head-on." - Mary Kom

10. "EVERY ADVERSITY, every failure, every heartache carries with it the seed of an equal or greater benefit." - Napoleon Hill

11. "RESILIENCE IS NOT about avoiding the storms but about learning how to dance in the rain." - Vivian Greene

12. "THE GEM CANNOT be polished without friction, nor man perfected without trials." - Confucius

13. "A WOMAN'S RESILIENCE is her most powerful weapon, turning setbacks into comebacks and challenges into triumphs." - Serena Williams

14. "LIFE IS NOT ABOUT waiting for the storm to pass but about learning to dance in the rain." - Vivian Greene

15. "THE STRONGEST OAK of the forest is not the one that is protected from the storm and hidden from the sun. It's the one that stands in the open, where it is compelled to struggle for its existence against the winds and rains and the scorching sun." - Napoleon Hill

16. "IN THE MIDST OF challenges, there is often the birth of extraordinary resilience." - Arianna Huffington

17. "A WOMAN'S RESILIENCE is her armor against life's adversities,

a shield that turns every challenge into an opportunity." - Maya Angelou

18. "OUR GREATEST GLORY is not in never falling, but in rising every time we fall." - Confucius

19. "THE HUMAN SPIRIT is indomitable. No obstacle is too great, no challenge insurmountable for a woman who believes in her own strength." - Audrey Hepburn

20. "THE PHOENIX MUST burn to emerge." - Janet Fitch

21. "A WOMAN'S RESILIENCE is a flame that withstands the strongest winds, lighting the path through the darkest nights." - Oprah Winfrey

22. "CHALLENGES ARE the fire that forges the steel of a woman's character, making her unbreakable and unbeatable." - Malala Yousafzai

23. "A WOMAN'S JOURNEY is not defined by the challenges she faces but by the strength she discovers in overcoming them." - Michelle Obama

24. "THE MOST BEAUTIFUL people are those who have emerged from the depths, forged in the crucible of adversity." - Elisabeth Kübler-Ross

25. "RESILIENCE IS NOT just bouncing back; it's bouncing forward, stronger and more determined than ever." - Arianna Huffington

26. "ADVERSITY INTRODUCES a woman to her true self, revealing the depths of her strength and the vastness of her resilience." - Maya Angelou

27. "A WOMAN'S RESILIENCE is not a solitary act but a symphony of courage, determination, and unwavering belief in herself." - Serena Williams

28. "IN THE FACE OF adversity, a woman discovers the untapped reservoirs of strength within her, proving that she is more than the sum of her challenges." - Oprah Winfrey

29. "THE OAK FOUGHT the wind and was broken, the willow bent when it must and survived." - Robert Jordan

30. "A WOMAN'S RESILIENCE is not just a response to adversity; it's a transformative power that shapes her destiny." - Malala Yousafzai

31. "LIFE'S CHALLENGES are not roadblocks but stepping stones, leading to the discovery of the extraordinary within the ordinary." - Michelle Obama

32. "IN THE DANCE OF life, resilience is the partner that leads us through every twist and turn, ensuring we never miss a beat." - Arianna Huffington

33. "A WOMAN'S JOURNEY is a mosaic of challenges, each piece contributing to the masterpiece of her resilience." - Maya Angelou

34. "THE LOTUS FLOWER blooms most beautifully from the deepest and thickest mud." - Buddhist Proverb

35. "ADVERSITY IS NOT the end of the story but the beginning of a new chapter, where a woman's resilience becomes the protagonist." - Oprah Winfrey

36. "THE PHOENIX RISES from the ashes, not in spite of the fire but because of it." - Janet Fitch

37. "IN THE TAPESTRY of life, challenges are the threads that create

the most intricate and beautiful patterns." - Arianna Huffington

38. "A WOMAN'S RESILIENCE is not measured by the absence of challenges but by her ability to navigate through them with grace and strength." - Malala Yousafzai

39. "THE ROOTS OF RESILIENCE are planted in the ability to face adversity and grow from it." - William James

40. "A WOMAN'S JOURNEY is a testimony to her resilience, a story written in the ink of challenges and illuminated by the light of her unwavering spirit." - Michelle Obama

AS YOU ABSORB THE PROFOUND insights within the "Overcoming Challenges" chapter, may you find inspiration to face your own obstacles with resilience and emerge stronger, knowing that challenges are not roadblocks but stepping stones on the path to your own empowerment.

Chapter 4: Breaking Stereotypes

In the symphony of individuality, the fourth chapter of "Rise: Empowering Women Across Generations" amplifies the voices of women who have shattered societal norms and defied gender stereotypes. These are the voices of pioneers who have ventured into traditionally male-dominated fields, celebrating the importance of authenticity, courage, and the relentless pursuit of one's true self.

As you delve into this chapter, prepare to be inspired by the wisdom of women who have boldly embraced their passions, proving that excellence knows no gender. These quotes challenge preconceived notions, encouraging readers to break free from the constraints of societal expectations and forge their own paths.

1. "I am no bird; and no net ensnares me: I am a free human being with an independent will." - Charlotte Brontë

2. "YOU ARE YOUR BEST thing." - Toni Morrison

3. "I AM NOT FREE WHILE any woman is unfree, even when her shackles are very different from my own." - Audre Lorde

4. "A WOMAN WITH A voice is, by definition, a strong woman." - Melinda Gates

5. "THE QUESTION ISN'T who's going to let me, it's who's going to stop me." - Ayn Rand

6. "DO NOT BRING PEOPLE in your life who weigh you down. And trust your instincts — good relationships feel good. They feel right. They don't hurt." - Oprah Winfrey

7. "THE ONLY WAY TO do great work is to love what you do." - Maya Angelou

8. "IT TOOK ME QUITE a long time to develop a voice, and now that I have it, I am not going to be silent." - Madeleine Albright

9. "THE MOST COMMON way people give up their power is by thinking they don't have any." - Alice Walker

10. "I AM DELIBERATE and afraid of nothing." - Audre Lorde

11. "THE ONLY LIMIT to our realization of tomorrow will be our doubts of today." - Maya Angelou

12. "NO ONE CAN MAKE you feel inferior without your consent." - Eleanor Roosevelt

13. "DON'T COMPROMISE yourself. You are all you've got." - Janis Joplin

14. "TO BE YOURSELF in a world that is constantly trying to make you something else is the greatest accomplishment." - Ralph Waldo Emerson

15. "YOU MAY NOT CONTROL all the events that happen to you, but you can decide not to be reduced by them." - Maya Angelou

16. "SUCCESS IS LIKING yourself, liking what you do, and liking how you do it." - Maya Angelou

17. "I THINK THE BEST role models for women are people who are fruitfully and confidently themselves, who bring light into the world." - Meryl Streep

18. "WHAT YOU GET BY achieving your goals is not as important as what you become by achieving your goals." - Maya Angelou

19. "I DON'T KNOW WHAT the future holds, but I do know that I'm going to be positive and not wake up feeling desperate." - Maya Angelou

20. "THE WAY TO ACHIEVE your own success is to be willing to help somebody else get it first." - Iyanla Vanzant

21. "A LOT OF PEOPLE are afraid to say what they want. That's why they don't get what they want." - Madonna

22. "THE ONLY PERSON you are destined to become is the person you decide to be." - Maya Angelou

23. "I'VE LEARNED THAT making a 'living' is not the same thing as making a 'life.'" - Maya Angelou

24. "YOU ARE NEVER TOO old to set another goal or to dream a new dream." - C.S. Lewis

25. "IF YOU DON'T LIKE the road you're walking, start paving another one." - Dolly Parton

26. "DEFINE SUCCESS on your own terms, achieve it by your own

rules, and build a life you're proud to live." - Anne Sweeney

27. "THE MOST DIFFICULT thing is the decision to act, the rest is merely tenacity." - Maya Angelou

28. "I'D RATHER REGRET the things I've done than regret the things I haven't done." - Maya Angelou

29. "I WORK REALLY HARD to just focus on the joy of the work that gets to be done and the impact of that work, rather than who's watching or how it's going to be received." - Shonda Rhimes

30. "YOU CAN'T BE THAT kid standing at the top of the water slide, overthinking it. You have to go down the chute." - Tina Fey

31. "I DON'T KNOW WHAT the future holds, but I do know that I'm going to be positive and not wake up feeling desperate." - Maya Angelou

32. "THE ONLY PERSON you are destined to become is the person you decide to be." - Maya Angelou

33. "I'VE LEARNED THAT making a 'living' is not the same thing as

making a 'life.'" - Maya Angelou

34. "YOU ARE NEVER TOO old to set another goal or to dream a new dream." - C.S. Lewis

35. "IF YOU DON'T LIKE the road you're walking, start paving another one." - Dolly Parton

36. "DEFINE SUCCESS on your own terms, achieve it by your own rules

, AND BUILD A LIFE YOU'RE proud to live." - Anne Sweeney

37. "THE MOST DIFFICULT thing is the decision to act, the rest is merely tenacity." - Maya Angelou

38. "I'D RATHER REGRET the things I've done than regret the things I haven't done." - Maya Angelou

39. "I WORK REALLY HARD to just focus on the joy of the work that gets to be done and the impact of that work, rather than who's watching or how it's going to be received." - Shonda Rhimes

40. "YOU CAN'T BE THAT kid standing at the top of the water slide, overthinking it. You have to go down the chute." - Tina Fey

AS YOU ABSORB THE EMPOWERING messages within the "Breaking Stereotypes" chapter, may you be inspired to challenge societal norms, embrace your authenticity, and pursue your passions with unwavering determination. Remember, your uniqueness is your strength, and by breaking free from stereotypes, you pave the way for others to do the same.

Chapter 5: Building Supportive Communities

In the tapestry of solidarity, the fifth chapter of "Rise: Empowering Women Across Generations" gathers quotes from women who have championed the strength of supportive communities. These voices resonate with the principles of trust, unity, and mutual support, encouraging readers to lift each other up, foster inclusivity, and create safe spaces that nurture personal growth and collective empowerment.

As you immerse yourself in the wisdom of these women, envision the power of communities built on empathy, understanding, and shared aspirations. The quotes within this chapter serve as a reminder that, together, women can transcend boundaries, break down barriers, and create spaces where every individual is valued.

1. "Alone we can do so little; together we can do so much." - Helen Keller

2. "WHEN WOMEN SUPPORT each other, incredible things happen." - Unknown

3. "A COMMUNITY THAT excludes even one of its members is no community at all." - Audre Lorde

4. "EMPOWERED WOMEN empower women." - Unknown

5. "THE BEST WAY TO predict the future is to create it together." - Unknown

6. "A WOMAN IS THE full circle. Within her is the power to create, nurture, and transform." - Diane Mariechild

7. "SISTERHOOD IS A powerful force for positive change." - Robin Morgan

8. "THE STRENGTH OF a community lies in the strength of its women." - Unknown

9. "A COMMUNITY THAT values its women values itself." - Unknown

10. "WHEN WOMEN COME together with a collective intention, magic happens." - Phylicia Rashad

11. "UNITY IS STRENGTH, and when there is collaboration, wonderful things can be achieved." - Mattie Stepanek

12. "A SUPPORTIVE COMMUNITY is a lifeline for every woman pursuing her dreams." - Unknown

13. "WOMEN SUPPORTING women is not just a hashtag; it's a way of life." - Unknown

14. "IN A COMMUNITY of women, every success is a shared victory." - Unknown

15. "WE RISE BY LIFTING others." - Robert Ingersoll

16. "A COMMUNITY THRIVES when its women thrive." - Unknown

17. "SISTERHOOD IS THE essence of all the wisdom of the ages, distilled into a single word." - Unknown

18. "THE BEAUTY OF A community lies in its diversity and the unity that arises from embracing it." - Unknown

19. "BEHIND EVERY SUCCESSFUL woman is a tribe of other successful women who have her back." - Unknown

20. "A COMMUNITY IS only as strong as the bonds between its women." - Unknown

21. "THE BEST COMMUNITIES are the ones where every member is seen, heard, and valued." - Unknown

22. "COLLABORATION OVER competition is the key to unlocking the full potential of a community." - Unknown

23. "A COMMUNITY THAT fosters the growth of its women is a community destined for greatness." - Unknown

24. "WHEN WOMEN SUPPORT each other, incredible things happen." - Unknown

25. "A WOMAN WITH A voice is, by definition, a strong woman." - Melinda Gates

26. "THE BEAUTY OF A community is in the acceptance and celebration of each woman's unique journey." - Unknown

27. "IN THE EMBRACE of a supportive community, women can conquer any challenge." - Unknown

28. "A STRONG COMMUNITY is built on the foundation of empowered women uplifting each other." - Unknown

29. "UNITED WE STAND, divided we fall. The strength of a community is in its unity." - Aesop

30. "SISTERHOOD IS NOT just a bond; it's a powerful force for change." - Unknown

31. "A COMMUNITY THAT nurtures the growth of its women ensures a legacy of strength and resilience." - Unknown

32. "WHEN WOMEN CONNECT, a wave of transformation sweeps through communities." - Unknown

33. "A COMMUNITY BECOMES truly rich when the wealth of support flows among its women." - Unknown

34. "IN THE MOSAIC OF a community, the contributions of women

create the most vibrant patterns." - Unknown

35. "A SUPPORTIVE COMMUNITY is a sanctuary where every woman can blossom." - Unknown

36. "THE POWER OF A community lies in the collective strength of its women." - Unknown

37. "WHEN WOMEN JOIN forces, the possibilities are endless." - Unknown

38. "A COMMUNITY BECOMES an unstoppable force when its women unite for a common purpose." - Unknown

39. "SISTERHOOD IS THE compass that guides a community toward compassion and understanding." - Unknown

40. "A COMMUNITY THAT uplifts its women ensures a future of boundless possibilities." - Unknown

AS YOU ABSORB THE EMPOWERING messages within the "Building Supportive Communities" chapter, may you be inspired to

actively contribute to and foster communities where every woman's voice is heard, valued, and celebrated. Together, women can create transformative spaces that elevate not only individuals but entire communities.

Chapter 6: Balancing Career and Personal Life

I n the intricate dance between personal aspirations and professional pursuits, the sixth chapter of "Rise: Empowering Women Across Generations" delves into the wisdom of women who have successfully navigated the complexities of balancing career and personal life. These voices offer insights into the strategies, values, and mindsets that have allowed them to thrive in both realms, proving that it's possible to pursue one's passions while maintaining a fulfilling personal life.

As you explore this chapter, envision a harmonious integration of career ambitions and personal well-being. The quotes within these pages serve as guiding lights, encouraging readers to embrace a holistic approach to life, where success is not solely defined by professional achievements but by the fulfillment found in meaningful relationships and personal growth.

1. "I want to do it all, and I want to do it well. But balance, that's a tough one." - Reese Witherspoon

2. "SUCCESS IS NOT about the position you hold; it's about how you balance your life." - Sheryl Sandberg

3. "YOUR WORK IS IMPORTANT, but so is the time you spend with your family. Find that balance." - Michelle Obama

4. "BALANCE IS NOT about juggling everything; it's about making the choices that align with your priorities." - Oprah Winfrey

5. "YOUR CAREER IS a part of your identity, but it doesn't define your entire life." - Malala Yousafzai

6. "SUCCESS IS ENJOYING the journey, not just reaching the destination." - Amal Clooney

7. "BALANCING WORK and family is an ongoing process of self-discovery and adjustments." - Arianna Huffington

8. "YOU CAN HAVE A thriving career and a fulfilling personal life; don't let anyone tell you otherwise." - Serena Williams

9. "THE KEY TO BALANCE is recognizing that your well-being matters as much as your achievements." - Indra Nooyi

10. "YOUR TIME IS A limited resource; invest it wisely in both your career and personal pursuits." - Melinda Gates

11. "YOUR FAMILY IS your constant support; never underestimate the power of their presence in your success." - Beyoncé

12. "SUCCESS IS NOT a sprint; it's a marathon. Pace yourself and enjoy the journey." - Angela Merkel

13. "HAPPINESS COMES from the harmony between your professional and personal worlds." - Emma Watson

14. "IN THE PURSUIT of success, don't forget to savor the simple joys of life." - Shonda Rhimes

15. "BALANCE IS NOT a perfect equilibrium; it's about making choices aligned with your values." - Jane Goodall

16. "SUCCESS IS NOT just about climbing the corporate ladder; it's about climbing your own ladder of fulfillment." - Meghan Markle

17. "STRIVE FOR PROGRESS, not perfection, in both your career and personal life." - Taylor Swift

18. "SUCCESS IS FINDING joy in every aspect of your life, not just in

your professional achievements." - Ginni Rometty

19. "YOUR FAMILY AND your passions are your anchor; let them guide your journey to success." - J.K. Rowling

20. "BALANCE IS A CONTINUOUS act of self-love and self-care." - Priyanka Chopra

21. "SUCCESS IS NOT a zero-sum game; it's about creating a life that encompasses all your aspirations." - Christine Lagarde

22. "YOUR TIME IS PRECIOUS; spend it on things that matter both in your career and personal life." - Ellen DeGeneres

23. "BALANCE IS ABOUT making choices that align with your values and bring you true fulfillment." - Chimamanda Ngozi Adichie

24. "SUCCESS IS MULTIDIMENSIONAL; it's about thriving in all aspects of your life." - Condoleezza Rice

25. "BALANCING IS AN art; it requires constant adjustment and a commitment to your well-being." - Michelle Obama

26. "SUCCESS IS NOT an either-or choice; it's about creating a life that integrates all your passions." - Ava DuVernay

27. "BALANCE IS ABOUT recognizing when to say 'yes' and when to say 'no' to create a life that aligns with your priorities." - Malala Yousafzai

28. "SUCCESS IS NOT about sacrificing your personal life for your career; it's about finding synergy between the two." - Misty Copeland

29. "BALANCING IS NOT about dividing your time equally; it's about being present where you are." - Amal Clooney

30. "SUCCESS IS ABOUT making intentional choices that reflect your values in both your career and personal life." - Oprah Winfrey

31. "BALANCE IS A DYNAMIC concept; it's about adjusting to the ever-changing demands of life." - Michelle Obama

32. "SUCCESS IS NOT just about the destination; it's about enjoying the journey along the way." - Serena Williams

33. "BALANCING IS NOT a one-size-fits-all; it's about creating a unique formula that works for you." - Sheryl Sandberg

34. "SUCCESS IS NOT about perfection; it's about progress and continual growth in all areas of your life." - Arianna Huffington

35. "BALANCE IS ABOUT recognizing that success is multidimensional and encompasses all aspects of your life." - Melinda Gates

36. "SUCCESS IS FINDING equilibrium between ambition and contentment in both your career and personal life." - Beyoncé

37. "BALANCING IS A journey, not a destination; embrace the process and learn from it." - Angela Merkel

38. "SUCCESS IS ABOUT harmonizing your professional and personal pursuits to create a fulfilling life." - Emma Watson

39. "BALANCE IS ABOUT making choices that contribute to your overall well-being, not just short-term success." - Shonda Rhimes

40. "YOUR SUCCESS IS unique to you; find a balance that aligns with your values and aspirations." - Jane Goodall

AS YOU ABSORB THE EMPOWERING messages within the "Balancing Career and Personal Life" chapter, may you find inspiration to navigate the delicate dance between your professional endeavors and personal aspirations, creating a fulfilling and harmonious life. Remember, success is a journey that encompasses both professional achievements and personal well-being.

Chapter 7: Self-Confidence and Self-Love

Embarking on a journey of self-discovery and empowerment, the seventh chapter of "Rise: Empowering Women Across Generations" delves into the realm of self-confidence and self-love. The quotes within this chapter, exclusively by women, illuminate the path to cultivating inner strength, embracing individuality, and celebrating the unique qualities that make each person extraordinary.

As you explore this chapter, let the words of these remarkable women resonate within you, inspiring a profound sense of self-assurance and love. May these quotes serve as a reminder that true empowerment starts from within, encouraging readers to embrace their authenticity and radiate confidence in every aspect of their lives.

1. "Your value doesn't decrease based on someone's inability to see your worth." - Unknown

2. "SELF-LOVE IS THE greatest middle finger of all time." - Unknown

3. "CONFIDENCE IS SILENT. Insecurities are loud." - Unknown

4. "YOU ARE YOUR BEST thing." - Toni Morrison

5. "THE MOST ALLURING thing a woman can have is confidence." - Beyoncé

6. "OWNING OUR STORY and loving ourselves through that process is the bravest thing that we'll ever do." - Brené Brown

7. "SELF-LOVE IS THE best love." - Unknown

8. "YOU'RE A WORK OF art. Not everyone will understand you, but the ones who do, will never forget about you." - Unknown

9. "CONFIDENCE IS NOT 'They will like me.' Confidence is 'I'll be fine if they don't.'" - Unknown

10. "THE MOST IMPORTANT relationship in your life is the relationship you have with yourself." - Diane von Furstenberg

11. "YOUR LIFE DOES not get better by chance; it gets better by change." - Unknown

12. "YOU ALONE ARE ENOUGH. You have nothing to prove to anybody." - Maya Angelou

13. "THE BETTER YOU feel about yourself, the less you feel the need to show off." - Robert Hand

14. "SELF-LOVE IS THE elixir of an immortal heart." - Amy Leigh Mercree

15. "CONFIDENCE IS LIKE a muscle: the more you use it, the stronger it gets." - Unknown

16. "YOUR LIFE DOES not get better by chance; it gets better by change." - Unknown

17. "THE ONLY APPROVAL you need is your own." - Unknown

18. "YOU ARE ALLOWED to be both a masterpiece and a work in progress simultaneously." - Sophia Bush

19. "SELF-LOVE IS NOT selfish; you cannot truly love another until you know how to love yourself." - Unknown

20. "CONFIDENCE IS NOT walking into a room thinking you're

better than everyone; it's walking in not having to compare yourself to anyone at all." - Unknown

21. "I RAISE UP MY VOICE—NOT so I can shout, but so that those without a voice can be heard." - Malala Yousafzai

22. "I AM MY BEST WORK—A series of road maps, reports, recipes, doodles, and prayers from the front lines." - Audre Lorde

23. "CONFIDENCE COMES not from always being right but from not fearing to be wrong." - Christina Grimmie

24. "YOU HAVE TO BELIEVE in yourself when no one else does—that makes you a winner right there." - Venus Williams

25. "YOU ARE ENOUGH just as you are." - Emma Watson

26. "I DON'T WANT OTHER people to decide who I am. I want to decide that for myself." - Emma Watson

27. "CONFIDENCE IS NOT a guarantee of success, but a pattern of thinking that will improve your likelihood of success, a tenfold." -

28. "YOU HAVE TO BELIEVE in yourself when no one else does—that makes you a winner right there." - Venus Williams

29. "CONFIDENCE IS NOT about being perfect; it's about being authentic." - Unknown

30. "YOUR LIFE DOES not get better by chance; it gets better by change." - Unknown

31. "LOVE YOURSELF FIRST, and everything else falls into line." - Lucille Ball

32. "CONFIDENCE IS NOT 'I'm sure everyone will like me.' Confidence is 'I'll be fine if they don't.'" - Christina Grimmie

33. "THE MOST BEAUTIFUL thing you can wear is confidence." - Blake Lively

34. "TO BE YOURSELF in a world that is constantly trying to make you something else is the greatest accomplishment." - Viola Davis

35. "I BELIEVE THAT the privilege of a lifetime is being who you are." - Viola Davis

36. "CONFIDENCE IS PREPARATION. Everything else is beyond your control." - Richard Kline

37. "SELF-LOVE IS NOT just important; it's necessary for your well-being." - Unknown

38. "YOU GAIN STRENGTH, courage, and confidence by every experience in which you really stop to look fear in the face." - Eleanor Roosevelt

39. "THE MORE YOU LOVE yourself, the less nonsense you'll tolerate." - Unknown

40. "CONFIDENCE IS NOT about being perfect; it's about being authentic." - Unknown

AS YOU ABSORB THE EMPOWERING messages within the "Self-Confidence and Self-Love" chapter, may you find inspiration to embrace your uniqueness, build inner strength, and cultivate a profound

love for yourself. Remember, you are a masterpiece in progress, deserving of your own love and admiration.

Conclusion

As we reach the final pages of "Rise: Empowering Women Across Generations," it is not merely the end of a book but the beginning of a transformative journey—a journey inspired by the resilient spirits and profound wisdom of women who have left an indelible mark on the fabric of history. In these pages, we've traversed through the corridors of leadership, witnessed the power of love and empathy, celebrated triumphs over challenges, shattered stereotypes, built supportive communities, balanced the intricate dance of career and personal life, and embraced the essence of self-confidence and self-love.

The stories and quotes shared within these chapters echo the collective voice of women from diverse backgrounds, cultures, and time periods, weaving a rich tapestry that reflects the universal experiences and aspirations of the feminine spirit. Each word, each sentiment, is a beacon, guiding us toward a future where empowerment knows no bounds and equality reigns supreme.

As we bid farewell to these empowering voices, let us carry their messages forward. Let the courage of leaders, the warmth of love, the strength in solidarity, and the wisdom of self-acceptance resonate within us. Empowerment is not confined to the pages of a book but is a living, breathing force that thrives in the hearts and actions of individuals.

The conclusion of "Rise" is not an endpoint but a call to action—a call to rise above limitations, to break barriers, and to forge a path toward a world where every woman, regardless of background or circumstance, can unfurl her wings and soar. The collective power of empowered women has the potential to shape a future where opportunities are

boundless, and equality is not just an aspiration but a lived reality.

May the stories and quotes within these pages continue to inspire, motivate, and empower you. As you close this book, remember that you are part of a legacy—a legacy of strength, resilience, and limitless potential. Carry this legacy forward, share it with others, and let the echoes of empowerment reverberate across generations.

For in the rising of each woman, we find the rising of all.

Suggested Further Reading

For those eager to explore beyond the pages of this book, we offer a curated list of suggested further reading. These resources include autobiographies, memoirs, and scholarly works that provide in-depth insights into the lives and contributions of the women featured in "Rise." This section serves as a gateway for readers to embark on a more profound exploration of the extraordinary individuals who have paved the way for empowerment.

<u>Women in Leadership</u>

1. "My Life So Far" by Jane Fonda - An intimate memoir by the iconic actress and activist, offering insights into her journey as a feminist and social justice advocate.

2. "MARGARET THATCHER: The Authorized Biography" by Charles Moore - A comprehensive biography of the UK's first female Prime Minister, delving into her political career and impact on global politics.

3. "BECOMING" BY MICHELLE Obama - The memoir of the former First Lady, chronicling her life, values, and experiences as a leader, wife, and mother.

LOVE AND EMPATHY

4. "Tiny Beautiful Things: Advice on Love and Life from Dear Sugar" by Cheryl Strayed - A collection of Strayed's advice columns, offering profound insights into love, compassion, and personal growth.

5. "DARING GREATLY" by Brené Brown - Brown explores vulnerability and the power of empathy, encouraging readers to embrace their imperfections.

OVERCOMING CHALLENGES

6. "I Am Malala: The Girl Who Stood Up for Education and Was Shot by the Taliban" by Malala Yousafzai - The inspiring autobiography of Malala, the youngest-ever Nobel Prize laureate, sharing her journey as an advocate for girls' education.

7. "WILD SWANS: THREE Daughters of China" by Jung Chang - A family history that spans a century of Chinese history, focusing on the lives of three generations of women.

BREAKING STEREOTYPES

8. "Hidden Figures" by Margot Lee Shetterly - The untold story of the African American women mathematicians who played a crucial role at NASA during the space race.

9. "NOTORIOUS RBG: The Life and Times of Ruth Bader Ginsburg"

by Irin Carmon and Shana Knizhnik - A biography of Justice Ginsburg, exploring her groundbreaking legal career and advocacy for gender equality.

BUILDING SUPPORTIVE Communities

10. "Sister Outsider: Essays and Speeches" by Audre Lorde - A collection of essays addressing issues of race, gender, and sexuality, emphasizing the importance of intersectional feminism.

11. "LEAN OUT: THE ELLESMERE Chronicles" edited by Elissa Shevinsky - An anthology of essays challenging traditional feminist narratives and exploring diverse perspectives on women in the tech industry.

BALANCING CAREER AND Personal Life

12. "Lean In: Women, Work, and the Will to Lead" by Sheryl Sandberg - Sandberg, Facebook's COO, explores issues of women in the workplace and provides practical advice for achieving career success.

13. "THE SECOND SHIFT" by Arlie Hochschild and Anne Machung - An exploration of the challenges women face in balancing work and family responsibilities.

SELF-CONFIDENCE AND Self-Love

14. "Year of Yes: How to Dance It Out, Stand In the Sun and Be

Your Own Person" by Shonda Rhimes - The creator of Grey's Anatomy shares her transformative journey to saying "yes" to life and embracing authenticity.

15. "THE GIFTS OF IMPERFECTION" by Brené Brown - Brown explores the importance of embracing vulnerability and imperfection to cultivate a sense of self-worth.

THESE BOOKS OFFER A diverse range of perspectives and insights, complementing the themes explored in "Rise" and providing readers with a deeper understanding of the challenges and triumphs of women across different contexts and time periods.

I INVITE YOU TO NOT only absorb the words of these phenomenal women but also to embark on a journey of discovery, learning more about the diverse tapestry of female achievement and resilience. May this list serve as a continued source of inspiration, encouraging you to rise above challenges, celebrate your unique strengths, and contribute to the ongoing narrative of empowerment for women across generations.

Don't miss out!

Visit the website below and you can sign up to receive emails whenever Maarja Hammerberg publishes a new book. There's no charge and no obligation.

https://books2read.com/r/B-A-DQKBB-WBRQC

BOOKS 2 READ

Connecting independent readers to independent writers.

Did you love *Rise: Empowering Women Across Generations*? Then you should read *Boundless Trailblazers: Inspiring Stories of Real Women Throughout History*[1] by Maarja Hammerberg!

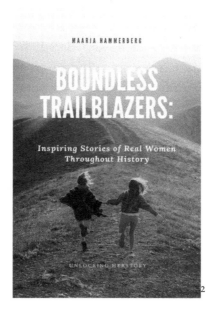

[2]

"Discover the Unbreakable Spirit of Women Who Shaped the World!

'Boundless Trailblazers: Inspiring Stories of Real Women Throughout History and the Present Time' is an empowering journey through the remarkable lives and achievements of women who defied conventions, shattered glass ceilings, and left an indelible mark on history. From ancient pioneers to modern trailblazers, this book unearths the extraordinary stories of female icons who have championed gender equality, made groundbreaking contributions in science, literature, and politics, and inspired generations.

Dive into tales of resilience, activism, and leadership as you explore

the lives of suffragettes, groundbreaking scientists like Marie Curie, literary legends such as Jane Austen, and contemporary figures like Kamala Harris. With a diverse range of stories, 'Boundless Trailblazers' is a tribute to the unstoppable women who have paved the way for progress and continue to inspire a more inclusive future.

Join us on this empowering journey of courage, determination, and the unwavering spirit of women who dared to change the world. 'Boundless Trailblazers' is your invitation to celebrate, honor, and be inspired by these extraordinary women. Get your copy today and let their stories ignite your own trailblazing spirit!"

Also by Maarja Hammerberg

Boundless Trailblazers: Inspiring Stories of Real Women Throughout
History
Rise: Empowering Women Across Generations

About the Author

Maarja Hammerberg, a dedicated mother of three young daughters, is on a mission to inspire and empower not only her children but the world. As a history graduate from the University of Tallinn, Maarja's passion for stories and the incredible women who have shaped history has always burned brightly.

Motivated by a desire to give her daughters the best start in life, Maarja has embarked on a journey to celebrate the achievements of remarkable women throughout history and the present. Her commitment to providing strong role models for her children and future generations serves as the foundation for her work.

When Maarja isn't busy being a loving and nurturing stay-at-home mom, she is a storyteller and advocate for women's empowerment. Through her writing, she aspires to kindle the same spark of determination, resilience, and courage in her daughters that has fueled her exploration of the unbreakable spirit of women throughout time.

With Maarja Hammerberg, the stories of incredible women are not

just tales from the past but beacons of inspiration for a boundless future.

Milton Keynes UK
Ingram Content Group UK Ltd.
UKHW020245221123
432980UK00016B/975